MW01043522

MOUTH

{ Mouth }

text by
CHARLES HOOD

with illustrations by
CHRISTINE MUGNOLO

Winner of the 2016 Kenneth Patchen Award for the Innovative Novel

Journal of Experimental Fiction 74

JEF Books/Depth Charge Publishing

Aurora, Illinois

Winner of the 2016 Kenneth Patchen Award for the Innovative Novel

Illustrations © Christine Mugnolo | www.christinemugnolo.com

Book design by Selena Trager

ISBN 1-884097-74-X

ISBN-13 978-1-884097-74-4

ISSN 1084-847X

JEF Books/Depth Charge Publishing

The Foremost in Innovative Publishing

experimentalfiction.com

JEF Books are distributed to the book trade by

SPD: Small Press Distribution and to the

academic journal market by EBSCO

CONTENTS

A note on the page layout:

The top voice belongs to Chica; her narrative is always left-right justified. The bottom voice comes from Bela; her lines are fewer and always begin bottom right. Chica cannot hear her: only we can.

"There has been a lot of spontaneous combustion lately."
"I thought that was just true love."

—Dr. Who

1.

I hated my teeth and they hated back and in the end a man with large hands and perfect hair told me, We can fix your mouth, Chica. But we have to break your jaw. You will know we have done it, for months you will know. The pain, yes. And it will change you.

We can fix your mouth but you won't even look like yourself after it heals.

I just said, I don't look like myself even now.

{ This can still end with sparklers and bagels. }

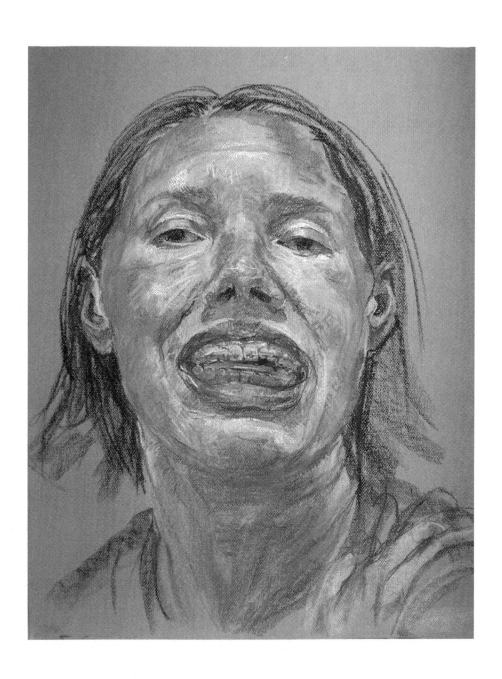

2.

My father could make pencils lift off the dining room table, cross the room, set down by his favorite chair quiet as a dove on a branch. Mama never knew, least I don't think so; she died when I was ten, never even learned English. She was Moldavian, with a mouth of bad teeth and a face like an icon. Russian, I had to explain to my friends, my mother was a kind of Russian.

That's about as useful as tits on a nun, my father said once when I told him about a new model phone. Strange man, infuriating and silent.

He could move oranges too. Car keys. A glass of water. I used to think it was normal. Mostly I still do.

{ *There is a tool called an Allen wrench, and a bird called Allen's hummingbird, and my secret hope is that they are named after the same person.* }

3.

Boston began in London. I was doing display cases for the Ice Age art show at the British Museum: big show, big money, big egos. Planning sessions went okay but too many Oxbridge accents for my taste. Just two Americans, me and this one slim girl not afraid to look me up and down, ready to bet the lame horse would turn into Seabiscuit.

At lunch we shook hands, she said her name was Bela.

As in belladonna, the plant?

She told me no, as in the actor, Bela Lugosi. Or maybe as in the porn star, you know, Belladonna. I was free to pick, she didn't mind.

Just call me Chica, everybody does.

That night she touched my lips, scars, breasts—

did it like I was first one, only one. We walked to the market and even the leaves glowed, the trunks of plane trees, the cellophane lemons at Sainsbury's.

She said Chica Paloma, do you want to go to Siberia with me, look for bones?

Well, maybe. This trip of yours, hard or easy?

There had been a thing in the Alps, rock fall and a speed ascent gone bad; that was why I was in London, working. I had to get better. My tongue played with my retainer while I thought. I had gotten bashed up pretty bad. Everything tasted like medicine except for her.

Do you know much about bones, she asked, and I said, well, I know what it feels like to break them.

{ *That would make this a love story then.* }

4.

She bit me, I couldn't believe it, half-circle bite marks on my shoulder and arm.

For one thing, she didn't seem the type, and for another, I needed to figure out what had happened, to get her to do it again.

{ *You make me feel brighter than a travel poster for India.* }

5.

One morning, and who the hell knows why, but I bought a new pack of Post-Its, wrote the names of different flowers on each one, stuck them all over the flat—fridge, back door, Cheerios box, spare loo roll under the sink. I did 42 before I made myself stop.

{ *Small pellets of sunlight pass through me, singing.* }

6.

When I was a kid we keened death arias in swift packs. We drove ugly cars, never used seatbelts. The night sky bled starlight through its burned holes like somebody holding a flashlight behind a gut-shot road sign.

We needed neither heat nor light, being lit from within.

In high school I was a babysitter and one of the sixth graders I used to take care of wanted to know if there were gay dinosaurs. Law of averages, I told him. Must have been. Or we can just wait and ask when we get to heaven, since if there are not going to be dinosaurs there, then I ain't going.

{ *The thing you most remind me of is somebody from* Mad Max, *Furiosa probably—or else one of the Land Rovers in* Born Free. }

7.

Diseases of the mouth:

this and this and this and this.

It's a long list, I had it in a notebook once, under the heading, "Why not to kiss, kissing causes cancer," and all the diseases of the mouth.

At 14, wiser than I knew.

{ *Well the sun causes cancer, and you don't hear it apologizing.* }

8.

I told Bela, pretending I was unsure, my father said never to go on trips to places so far from home you can't walk back if the car breaks down.

Bela said fiddlesticks, this was not a trip, it was a quest: bones hold up the roof of the world. We would dig some up, not just some, but the best ones, use them to hold the tent of the sky just a foot or two higher than it is now, make it so the polar bears didn't have to bend their heads so much. Not stealing, just helping. A holy trek to discover the basement of the sky.

Soon it was clear that for her it was not so much bones, but tusks—if you know where to go, there are a lot of mammoth tusks out there she told me, ivory trees poking out of muskeg and permafrost.

Yes, I said, I know. Gulags and extinct animals, I get that part. So just how much is it worth, I asked, this fossil mammoth tusk.

Don't be a noodlehead. It's not a *fossil* tusk. You don't need the adjective. It's not like there are some living mammoths we might get it mixed up with. Just one thing only, a tusk, singular, and it's not to sell, it's to have. For my house. And you, train wreck Chica, you are the kind of girl who knows how to wade out with shovel and pry bar into the wettest bog of the worst tundra in the world and get one for me.

That I am, Bela.

That I am.

{ *Even the broken bone has a memory of being whole,* }
{ *will corkscrew all it can to grow back together again.* }

9.

We are, most of us, Thursday inside—end of a long week and will Friday never come. The first thing I ever moved was a jar of pennies. I *think* I did it: my eyes were closed, my head about to burst from trying so hard. Miracle Whip jar of loose change on top of the fridge, and I could hear it—

one inch left, one inch back, then two inches, then four over and back, I could hear it so clearly in the empty house. At first I thought the worse thing was being gay. Then I realized there are darker secrets.

Even now, all these years later, if I can't sleep I close my eyes and listen to it over and over,

scritch, two inches left, *scritch*, two inches right.

{ *Lucky jar, lucky money.* }

10.

Another thing my father taught me was how to name dogs. This reason or that we ended up with five, rescues one way and another, or as he said, show me one person who's not a stray at one point in his life and I'll show you a liar. Haiku, he called her, naming our smallest. So what's haiku I asked, and he just smiled and said a haiku poem, my illiterate daughter child, is a paragraph full of bottle rockets.

Dad's favorite was a blind pointer named Lapua. I was 12 or 13 maybe, said, that sounds Hawaiian, what are we going to do, feed it poi for dinner? No, smartass, he said, it's Finnish, a kind of bullet. Snipers use it. Confirmed kill at 2,707 yards, which is easily the distance this dog can hear us put food in his bowl. Now shut up and get me some batteries, this remote just eats them like candy.

{ *I asked you what rhymes with fork and you answered,* Torque, why, what *does it rhyme with for you?* I said, Cork, Pork, Dork, Bjork, Peter Tork. }

11.

Once outside a bar in Fairbanks a man wanted to rape me. I think he may even have known I was gay, and that could have been part of it. Some people, their wicks are so twisted tight, it's hard to know what will make them blaze up.

Five nine and not usually a plus size, and top that with the fact that I work out like crazy. Hell of a lot stronger than I look. But that's not it, nor was having been in all those fights growing up.

Somehow I heard him coming, could hear his body in relation to the gritty snow, could feel the bones in his hands flexing and tensing as he crossed the parking lot.

Police said he died on the way to the hospital, sort of asked nicely, was I planning on being town long or maybe there was someplace else I might rather be.

{ Anywhere but here, *that's what it should say on each of our t-shirts.* }

12.

Bela had connections. Free North Face swag, free plane tickets. Visas of course: art professionals, essential research. The food we could handle once we got there, boots and shovels, maybe a rifle. I think a certain amount of prevarication had traded hands, who we were, what routes I had climbed, which museums we represented, the overall trend of goals and outcomes.

We were staying in Cornwall before we left—a trustee had a weekender—and she wanted to play the answer game. She said, so define beauty.

About to quit right there. It just seemed so fake, her trying to say she liked me just fine, any way I was.

I said, you know why most unicorns have broken horns? It's not from fighting other unicorns or stabbing leopards. It's the salt. It's from prying up the ground at mineral seeps, digging out the mud with their horns, to open up a salt lick for themselves and other equines and ungulates. You look at nature, damage is the normal state of affairs. Most animals are really beat up, if you stop to look closely at their faces.

Bela walked to the other room, didn't answer, but I heard her plugging in the coffee maker. When the grinder started, the beans sounded like a small, angry helicopter tangled up in tinsel. Then a low voice, almost singing: Driving west at the end of the day, most all the things we ever experienced are just the smears on glass that turn the sunset into diamonds. It's not about the drive, it's never about the drive. It's about what kind of goggles we need to get ready for the flying diamonds.

{ *In archaeology, these memories are what they mean by overburden.* }

13.

You get used to it. Eleven years old: first bone I ever busted was just a classic arm break, crack, right in two, though not a compound fracture or anything complicated. I was building a one-woman Temple of Jericho out of cement and chunks of white sandstone, up on the bare ridge behind the firing range. These things happen.

I rebroke the same arm a month later, hitting Kevin Larson with my cast across the top of his head for saying I was so ugly I had to poo from a ladder, so not to scare the toilet water.

Broke an ankle once in a fall on Denali. Forty-two hours it took, crevasse to air evac. I was popping Vicodin like Christmas candy. Two car accidents: one my fault, one not. Hands and ribs, respectively. Thirty-two stitches, motorcycle, Highway 1 near Big Sur. A dog bite, not my fault. Couple big pendulums, North American Wall, Yosemite. These things happen.

My dad helped pay for the mouth surgery, said, hell, it was partly his fault: he talked so much smack over the years, his crooked mouth went and got hereditary on him.

God, the radiologist was so hot. I wanted to do her right there, androgynous blue scrubs and everything. I told her, I bet you are naked under that top, and she said, you got nothing to bet that I want. But when she put my head in the vise for the before shots of the before-and-after panorama, her fingers lingered behind the ears, on my jaw line, too long against my neck. God she was hot.

Six months, surgery to recovery. Worse than the ankle from Alaska. I dated her that whole time even though she was cheating on me with some butch kickboxer. Then just like that, I left her for London. Hemingway once said

about losing his third wife for the fourth, *live by the sword, die by the sword,* and he should know, he collected enough bent steel. Some people are smooth and reliable as beach stones; some of us though, who knows why, we're just a mess of glints and hilts.

{ *Teach me how to allow everything in the world and I will.* }

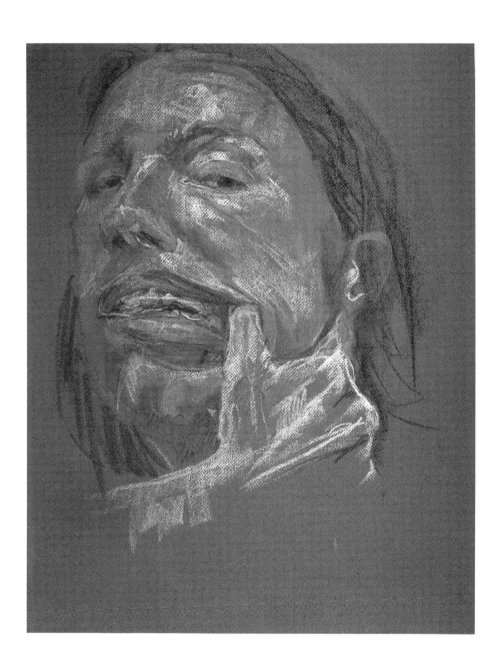

14.

Time to go. Not even light yet, and an Addison Lee taxi double-parked out front. Goodbye, note for the landlord. Goodbye, voice that says, over and over, *Did you forget anything?* Goodbye, crack in the tile by the door. Goodbye, neighbors—

{ *I hope our lovemaking kept the whole building awake.* }

15.

Landing, passports, shuttle van—we were, finger quotes, "there." So this is Russia. No wonder my mother left. Slushy snow and restaurants with stuffed wolverines whose taxidermy snarls looked like strangely stage-fake Halloween grimaces. Rusty trucks, rusty people, rusty smell to the cold, Russian air. Even the children leaked smoke.

I wanted to eat, take a shower, ah no, Busy Bee had plans.

Not about eating or sex or the romantic gestures waved over the lost graves of lost poets. Her plans involved the inevitable connection meeting us in some dive without a name that served watered-down Stoli in glasses that had not been washed in weeks. It had red and white vinyl tablecloths and one plastic yellow flower, and it looked like an exquisitely probable place in which to get beaten up and left in a dumpster.

How much, she asked him. Big guy, bad teeth, straight up central casting's idea of how to tell the audience, "this one's bad news."

No, he didn't want to help; he was going to charge triple; he was going to turn us in; he would take our money then rape us—you could see, options were at play behind his thick forehead. Bela was unfazed, just did her *these are not the droids you're looking for* mind trick, all was fine.

Had she really done that or did I just make it up? It was not the place to ask. She stood up. Money changed hands. He counted slowly, as if the bills would turn out to be sedated butterflies about to wake up and fly to the tip of his nose, antennae waving.

When we shook hands at the end, I gave him all the juice I had, watched his eyes go just a little bit wider.

Okay, I told her, it's time. Now we eat.

{ *The glasses were so alert they looked clean in spite of themselves.* }

16.

The dogs got sick off the meat. People forget that. 1901, Beresovka's expedition to exhume a mammoth carcass fed the thawed meat to the dogs. But they all got sick after. Some things may look good but still be too far gone.

Facts about having the doctors break your mouth and make a new one:

You will vomit blood, except your mouth is wired shut, so you mostly spray it through the gaps. The rest puddles in your mouth or drips down the openings onto your shirt.

You have to sleep sitting up.

It will be a month before you can eat applesauce.

The bruising shifts in topographic waves down your face, your neck, your chest. For weeks the blues and greens bloom and shift, heading south.

Deep inside, the bones hurt, benthic connections of ache and groan. On the outside, though, the skin is numb but supple and you still can't smile—the muscles have been cut, nothing connects up anymore.

The first time you make out—this will be many, many months later—it will feel like landing on the moon.

The first time you try to talk about it with somebody else—also some months later—there will be no language to describe the Exodus and loss, the return and the rehabilitation. The next time though, and all the times after, nobody really will be listening. They'd don't want to hear. We have

sympathy for the ill and the deformed, but mostly revulsion. *Thank god that was not me.*

Facts about mammoths:

Their ears were the same shape as human ears.

Small ones have a kind of baby tooth called a milk tusk.

Like humans, at times they died with food in their mouths.

An erect penis would have been pink. It had flanges of a sort—structural ridges, support struts, circus pole guy lines. A bull mammoth's penis was just under three feet long and seven inches thick.

A pair of skulls once were found, both males, with the tusks interlocked. They had been dueling, got tangled up, died.

Like prostitutes in Moscow, mammoths had red hair.

Tail like a flywhisk.

Talismans, ax heads, pitfall traps, scallop-edged chert: humans may not have been the first cause of extinction, but if not, they tried hard to be second.

My mother told me that on St. Michael's feast day one cannot thresh wheat because the souls flying through the air might be injured. What if that's not just one day of the year, but all of them? In the tradition of the tundra people, deceased mammoths are examples of a kind of still-living

but mostly-subterranean mole. The bodies are found by hunters buried in the ground because the animals usually live in the ground, as evidenced by the dirt in their eyes, their deeply tangled fur, the bound-feet slave curve of their ingrown tusks. Sometimes, who knows why, they come to the surface, become stranded like whales on an ebb tide. Caught in daylight the mammoth-moles died, their bodies bent in agony and desiccated by sunlight. In such a case, if you come upon one, leave a silver bead in the mouth and go away. Do not stay long.

It is always best not to look too deeply into the faces of the newly dead.

{ *Chekhov: "Strange, all this grief and then pancakes afterwards."* }

17.

The deal on tusks is this. It's not necessarily illegal to hike around and look for them. Nor is it illegal to dig them up, wash them clean in an Arctic stream, haul them around a while, wrap them in plastic, ship them another place. Once home, it's not illegal to have one in your living room. But it's not legal, either. None of it. Get caught by the horse soldiers or the helicopter soldiers or the visa checkers or even a bright-eyed, not-on-the-take Fed-Ex clerk and it's goodnight Charlie. You will be writing volume two of the history of Soviet prisons in no time.

Not that I much believe in downshifting for corners. Slow is not an interesting speed.

{ *The border guard's uniform was a dark, blurry green, like a tattoo underwater.* }

18.

Long waits for the flights north to bone land. Bela had gone to a shop to buy more candy and some bottled water. I watched the bags. Thinking is bad for people and I was mostly thinking about the woman in the Happyland Bar in Moscow, the woman Bela did not know about, the woman who took me to her room and said, *Every wound always has an exit point and so where are yours, Chica Paloma, show me, show me so I can kiss them, so I can touch them, so I can enter each wound*

 and come out the other side.

{ *If we were both as transparent as fish, it would be easier to find your heart.* }

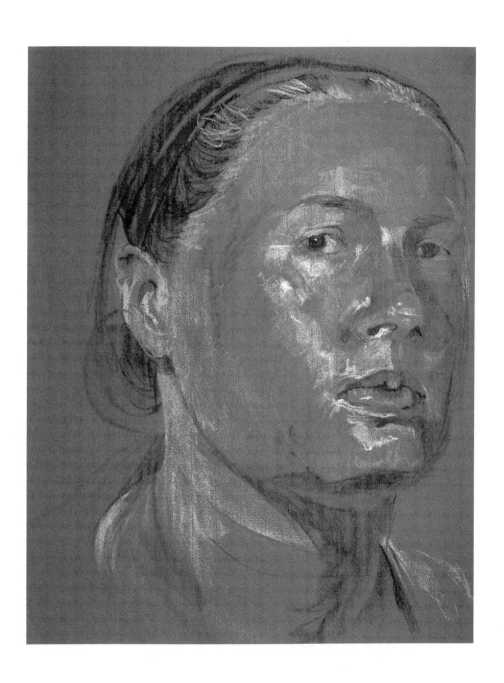

19.

We took a logging truck, a helicopter, a boat. And then we walked. Spring thaw snow, epic and boy how. When it got tough I carried part of her load—I know how to shut up and haul. We set up a temporary base camp by a stream, in a little hollow out of the wind, then we built a trench-cabin with sod-and-sapling walls, woven-mat floor, the roof camouflaged against the helicopter police.

We ate a fox we trapped with snares. We ate wild salmon called char. We ate canned peaches.

Giddy with arrival we named the new plants: *piano grass, lemon seed, bone flax*.

In less than a week we finished building a cabin and an outhouse and on white canvas drew a large-grid version of the topo map and made plans for looking for our tusk. Big ones weigh 175 pounds. Could we carry it ourselves? We would have to. Carry or drag it. First we made the roof secure, watertight, invisible. We cooked small, dense loaves of bread in a Dutch oven. We made potato-jerky stew. The days got longer.

{ *Each day the sun circled the cloudy horizon like a nearsighted bear, trying to look into the cabin, trying to figure out what we were.* }

20.

And then he was just there, a strangely sensual tattoo-faced man-woman came to trade us wild parsnips and fingerling trout for salt and ammunition. We had shotgun shells but no gun—one of those screw-ups in packing—so it was easy to match his offer. But we each looked twice when he came to the door: man or woman?

Voice, size, Adam's apple: man, we decided, voting silently with a look.

Beautiful as summer grass.

The name was difficult, was he saying his name was Uquiat? Yukyatt? But another part of his name was Qymska, something like that. It was agreed we could call him Uqi, that was fine with him, it had something to do with the sea, we were not sure.

He looked Inuit, Mongolian, wild. Tall, direct. His body fit his body, as my father would have said. He had tattooed dots running down each cheek. Bela made him instant coffee, then broke a chocolate bar in three.

He said thank you. He said, maybe you will know me. I'm the one, so. My wife is died. Her, she is one. I have died her, yes. You know of me?

Bela said, we are both sorry. How did it happen?

We were speaking Russian; all of us had to go slow, like crossing a stream rock to rock to rock, careful not to fall in. Bela had done three years of it in school, was the most fluent of all of us, but even hers came and went.

There was a pause.

Bela thought maybe she had said it wrong, said again, sorry, how did it happen?

She grew antlers.

Your wife grew—*antlers?* Horns of caribou? On her head—? We put our hands up, both of us at the same time, as we tried to get the words right.

He picked up a red colored pencil, drew a picture on the edge of a map. A woman in boots with antlers.

Yes, we see, Bela said. But she didn't, she couldn't. Even I barely did.

It was in rain, he said. I thought she was caribou. I shot her. I said, it is dangerous. Stay by camp. Maybe she was shame in case somebody came. Maybe she wanted to find others like her kind. I did not mean it, but happened, this thing. I shoot her.

He seemed so calm, but the craziest ones do. Calm and sad. Threat or harm? My dad used to say, that one, you give him a whole lot of leave-alone. But no—anybody that beautiful, that centered, couldn't be a problem. The tattoos on his face glowed like small green stones.

He said, I made grave and I bury it. Then the horse police made me leave. I came out here, to live alone. Trade ivory, I take feathers of the marsh duck, I take the rich ones to hunt bears. And now I have met you, the bone women.

How do you know us?

Everybody knows you.

Even the helicopter police?

Not them.

Cautionary, "go slow" looks shuttled between us.

Bela waited a long time and finally said, look, we hate to ask. But. So, do you know where the tusks are?

He looked sad, carved from oak. He said, I think she talks to buried things. Through the ice. Through the mud. If I see her—and she is come, sometimes, during the day, she is come by—I will ask. We have talk signals. We have a signal, if I see her far off and I need her to stop and be still, have a signal for her to stop and speak by me.

Then he held up his bare hand, fingers upwards, as if he wanted us to help him put on a stiff glove. He said a little word—we could not hear it, but not Russian—and all of his fingers caught fire like candles. He stood there with his hand burning for just a moment, then made a flourish, and as he closed his fist, the flames went out.

No bad smell, no wince of burnt flesh.

He looked calm, normal. And he smiled at us each, bowed, and left.

{ *All of those semesters of Russian and I never got less than an A-,* *and then one day things no longer have words, not in any language.* }

21.

Vitamins and aspirin.

You said, name two things we brought more important than guns.

Three, if you count a deck of cards.

{ *And a ribbon for your hair—be beautiful, Chica,*
I know you know how. It's not always a knife fight. }

22.

Some days hope folds into your hands like a tame bird. I don't know why, but after a week certainty came in the night like a good dream and I knew that I would find something huge and interesting that day.

Uqi had suggested some of the better stream cuts to try, places to start until we got help from the spirits of wives past or however his juice would hook us up. But for me, I didn't need to wait, I just woke up certain. *Today.*

I just had to lace up my boots and go make it happen.

\lbrace *You left in such a happy hurry the clouds followed you like dogs, eager to see what all the fuss was about.* \rbrace

23.

I went farther east than usual, across to a small river that cut at an angle down to the coast, and in an undercut bank, ten feet down, I saw the first thick, yellow bone.

Yes.

In our packs we each carried tools: a folding army-surplus shovel, two kinds of pry bar, and, used as a walking stick, a longer, heavier steal bar. This was not trowel and whisk archaeology but the brute labor of digging a freight train engine out of block of frozen mud the size of an apartment block.

The bones were at an awkward height, out of reach from above, too tall from below. I stood in the horrible cold water of the river and I worked without a break but in two hours I knew I was wrong.

Pleistocene, yes, but not a mammoth. No tusks here.

And not even wooly rhino, mammoth's cousin, but a huge and useless steppe bison, the skull broad and stupid, as bovine as could be. Not even valuable as a specimen: from the La Brea, from digs in Russia, bison are dirt common. Some regional museum might want one, but really, not even worth the price of the bribes needed to ship it out.

One hand was cut, where I had caught it on an edge of ice. There was a welt on my head, from falling. It began to rain. When I was done screaming at the sky and done crying, after I had eaten some bread and had coffee, I took the parts of the skeleton I had already extracted and made a small cairn with them. I left a triangle of fossil abalone at the very top and began the long walk back to the cabin.

{ *I love you more than Mexican fireworks.* }

24.

That was when the bones first began to talk to me.

{ Cloudy night but even three or four stars can be enough to find the way. }

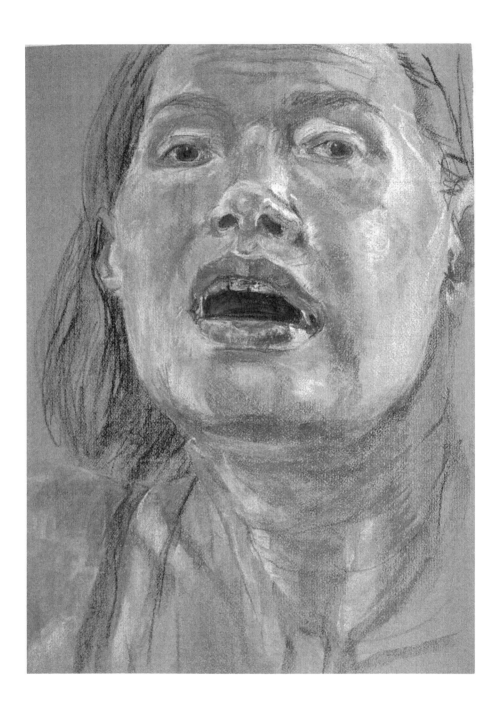

25.

I needed to be sure. Such a cliché, to claim women have intuition, that earth mother hokum. Yet in time I began to hear the land, the water, could guess where the eider duck nests would be, the shed antlers of caribou.

I found myself circling the same piece of folded ground for hours—so close, around somewhere, I could hear it singing to me, somewhere close, but where?—it felt good though to be alone, inside the rhythm of the land.

Let my love be ivory, I thought.

Even if it comes out of the ground bent and ugly and stained brown as motor oil. My love has to be ivory.

{ In my dream once we were each fireflies but we were as big as bats. People came a long way just to see us. }

26.

A cup of coffee, still warm. A cup of coffee left sitting on the plank-on-barrels table.

But—

how could there. We did all the dishes before we went to bed. No cups left behind, no coffee left simmering. None of it.

Bela: *are you sure you didn't get up? Maybe you sleepwalk.*

We tried to use logic. It was raining, yet no boot prints, no smell of wet wool, no smell at all, except us, our smell, same as always. Nobody had been in or out.

The world bugs the shit out of me some days.

{ *Some days I am so small I become invisible, and I take you with me.* }

27.

Love and spit. Spit in the air and turn three times, saying words.

For three days Uqi came, each time with food, and we ate together and did not talk much, never touching, heads down, spoons in bowls, like peasants, like simple things, like holy and penitent saints, and I watched him, careful like an animal, making sure not to say the wrong thing, but on the fourth day it was different, and he came early, and he said, *She has told me. I know the place. We go there. Today, we will go. Today we will find a good one.*

{ *The blue part that looks accidental will train the rest of the painting to look like sky soon enough.* }

28.

Bela and I kept talking about it. Later neither of us could remember exactly how we got there, to the fossil site, to a beach on the coast that gave us rich presents.

Did we fly?

It was so hard to be sure: at first it was just Uqi and me and Bela, we just were walking and the ground as usual was soft and wet, bright with small flowers and some feathers where a fox had killed an eider drake and then the tundra pulled away from us and we went a while, maybe half an hour, bent over like floating, speeding sticks, the wind coming into our mouths almost too strong to breathe, and it seemed a fourth person was with us, somebody just behind, then no, somehow we were down, just three of us again, standing on the ground again with three iron pry bars and some rope and our two backpacks with their worn American logos and useful, practical, mundane straps and their dried mud streaks like tears, and Uqi just said, *yes, here. It is here.*

We were at the coast, low tide, the sand black and silty, fine-grained like dark clay, with a slabby cliff fifteen feet tall, also gray, and the ocean behind us was gray and the sky today was gray and some dark-backed gulls beat past, and there were pieces of hard white ice mixed in with bleached driftwood around our feet, and the smell of salt air, and some bladder-pods of kelp washing in and out on the small, neat waves.

Uqi looked worried, looked at the cliff, looked out at the sea, finally said, wait here. He walked up and down the narrow beach, fifty yards in each direction.

Beach then cliff: no escape route. We had maybe three, four hours, then this all would be awash. A good place to look for whale bones and a good

place to drown. Bela was already picking at the cliff face closest to us but by then I knew, I was *certain*, it was here but not where she was, not there, but it was close, our gift was close. Where, though? I tried to listen harder than I ever had before.

I closed my eyes, stretched out my arms like Jesus on the cross or maybe just like the yardarm of a wrecked ship, and listened, listened. I knew. I could hear my own blood rushing up and down the elevator shafts of my head, I could hear the gulls screaming to one another *hunger and anger, hunger and anger*, I could hear a colony of voles harvesting tussock shafts on the cliff-top tundra. I could hear the sea surge pushing the cobbles around ten or twenty feet deep in the tide that was waiting to turn, and could hear Uqi half a beach away, walking slowly and looking for signs, talking to himself in Yakut. He too knew we were close, was trying hard to find it, and I wondered if he even knew himself that he was doing it just for me, and that I was doing it for Bela.

Not a specific word yet certainty: I heard then with final clarity the ivory tusk tell me where it was, that it was time, we could start. I went to the correct place, about thirty yards down beach from Uqi and Bela both, and so I wouldn't get disoriented later, drew an arrow in the wet sand. *Here.*

Five feet up, five feet in. *Here.*

I began to dig, saying to the others, come, come now, come quickly.

We had the passion of belief. Maybe it was my own certainty but there was no dissent. Bela the Backhoe I wanted to name her: for a curator, she sure can put her shoulders into it when the time's right. And Uqi's totem must be the mother bear about to den. Fire hoses could not have carved out the face better than we did. First just a thick brown fist of promise like an oak

root, then soon more, more, a foot of tusk, a foot and a half. I had stopped listening just to dig. It seemed huge, like it would take us back into the cliff for miles. The ivory looked to be in fabulous shape and we were careful to work in close and not to strike wildly; nobody wanted to be the first one to chip it or even leave one long, marring gouge.

The more we uncovered the more it became a festival, each of us giddy—knuckles scraped up and everybody laughing and crying and hugging and then going back to hack more into the frozen silt, peeling it back in chunks, digging ourselves an escape tunnel from this world into the next.

After one hour or maybe ten—we couldn't tell for sure, and the tide seemed not to have changed the whole time—the tusk was free, it was out, huge and curving, an amazing spiral of ivory victory that Bela said must have come from an adult male. How old was it? No guessing, she said—a few thousand years, twenty thousand years, impossible to know, really. The surface was clean and smooth, traced with fine grooves and glowing under the flat light with a lustrous tea-brown color. It was like it had its own internal light, something it used to stay warm those long years under the ground. We struggled, laughing—it felt like it weighed more than a horse—as we carried it down to the frigid sea and washed it clean with numb hands and a red handkerchief. Bela had brought a surveyor's tape: 231 centimeters, about seven and a half feet, measured along the curve of its main arc.

Now what, I said.

Uqi: now we go in the boat.

Even Bela looked skeptical. He pointed, and yes, he was right: if you shielded your eyes and squinted out to sea, there was a dory or Boston whaler

or leaky bathtub or something coming in toward shore. When had he arranged it? He would not say.

Some money, some brief hullos in Yakut, two men in hip waders with faces as round and perfect as Inuit carvings. They shared around a cigarette, accepted a drink, then we loaded. Along the coast an hour, into a lagoon, up a river, sometimes lifting the outboard to push over shallow gravel bars. At one point we thought we heard the helicopter police, waited tied up under a bend in the bank, all of us covered by a grey tarp. Home late that night, almost too tired to imagine making love.

The tusk we wrapped in oilcloth and buried behind the fuel cache.

We asked Uqi to stay, saying we would cook, give vodka, make party, but he shook our hands, accepted only a small bundle of sugar and tea, left.

If I could have set my hand on fire to wave goodbye, I would have.

{ *When I am happiest I want to have a bandito mustache and a belt filled with cartridges all the way around.* }

29.

Wings so black they look green—how a raven looks in morning light.

She said her class had a pet raven in sixth grade. It ate Vienna sausages, potato chips, worms, bruised slices of apples. It bit the tip of a girl's finger right off.

We were filling in the gaps, what we thought the other didn't know. She also said that her father had been a member of the Benevolent Protective Order of Elks, that he had been left-handed, that he had died in his sleep, and that his hobby was collecting vintage Christmas Cards that he kept in leather albums. The last time her mom had checked, they appraised for $30,000.

Then Bela reached over tea and bread and brushed my face, saying, I know how you are. Some days when I reach out and touch your face, my hand goes all the way through. You are lovely but gone. Don't worry, I am used to it. I just wait a few hours, and somehow you always find your way back.

{ *I collect the lost pen caps I find in motels, copy centers, conference rooms; I put them them in a special drawer. Last I checked, I had over 200. They all just need a friend.* }

30.

Maybe we were not meteors, she is not and I am not, we are not burning smears in the night sky, but the kind already on the ground, not shooting stars but meteorites, pieces of outer space spread across a desert saltpan. Children would be happy, finding us.

Bela usually slept well; I was awake, laying next to her on our pallet bed and moving the box of salt on the table back and forth, slowly, quietly, just something I did to stay calm. I sure as hell was not going to wake her up. If we were each something in an astronomy textbook, what would we be? If we were animals in the zoo, which one would be her, which one would be me?

I remembering thinking that if Bela could do things like that herself, maybe just bend will even a little bit, maybe it couldn't work on me. Had she even tried? Maybe that was why she loved me so much: I was behind a wall, but in a way that made me real, something she could trust because it was beyond control.

I tried to imagine reducing myself down to a pencil point, down to a circle even smaller than that, down finally to the size of a supercharged particle so that the cosmic rays pushed me through the skin of the earth. *Oh how small I am, safe and hidden, nobody can see me. Sshhh, you are sick mama, just sleep, I am nothing now. Listen to how quiet I can be for you.*

{ *Yet it is still hard not to be sorry for pencils, smaller every day.* }

31.

Not yet, he said.

Uqi came and told me, five more days. Something about the river, boats on the river. Sleds and a truck. Not today but five days. Bela was gone, trading, but would be back, we would go then.

After he left it felt almost too quiet. In the small mirror I counted my teeth. Who *are* you, I asked each one.

They knew and would not answer.

If you could sleep with the most beautiful person in the world, think how ugly that would make you feel.

That might be reason enough to do it.

{ *There is a dragonfly called flame skimmer but you always want to be* flame diver. }

32.

Bela came back just when I began to miss her bad. She brought jars of lo-
ganberry jam, more coffee, a salty wad of smoked fish. We kissed and we
washed each other in the metal tub, standing breast over breast to pour
water from the kettle over our shoulders, our bellies, the curves of our
plain white bottoms.

Look at me, I've lost twenty pounds, Bela said.

Then we stopped.

It was a terrible, burning *oh no* certainty: right away we knew. We could
both hear it. We were sure. At least two helicopters, big ones, military:
not oil exploration, not hunters, the noise was swelling, they were coming
right for us. Big ones, coming right here. We pulled on jeans, boots, we
ran to cover the tusk's special hole with more netting, more fuel barrels,
but it was too late.

Helicopter police: two huge Army choppers. In less than a minute
they had landed, rotors still turning as boots cleared skids, and as soon
as they touched down they were on top of us. Assault rifles, helmets,
shouting. No place we could go. We had never even bought a hunting
rifle. They turned over the hot water, poured it on the floor, smashed
jars with their rifles. Bela was trying to talk to them, explain, offer a
bribe, just museum women, this is nothing, saying *please, please.* The
captain knocked her down and I went after him and they covered my
face with their hands, kicking us, shouting, breaking the chair, saying
we know you have it, where is it, shouting in Russian but some words
in English, screaming in English, you fucking cunts, you cunt bitch
dogs, we know you have it, where is it. They blotted my face with huge
hands and kicked us and shouted and then somehow it stopped: from

the tusk hole there was a different kind of shouting, some boy, some excited boy had found it, was pulling it out, more noise, boots going out, and after a final hard fist against my face, they left us both there, collapsed on the floor.

They did not kill us. They did not set fire to the cabin. They did not take the fuel or the last of the food or even our money or passports.

But they pulled it out of its hole and unwrapped it from the oilcloth and they put their filthy hands all over its smooth perfection, and they took it. They loaded the tusk into the first of the two helicopters and lifted off, and three or four minutes after we first had realized they were here, it was over. They were gone.

They took our beautiful perfect tusk and were gone.

{ *The quietest sound of all is what the air sounds like* *after a helicopter has lifted off and gone away.* }

33.

Half a day before I could do it, but I finally said to Bela, okay, help me get up.

We had to fix it, clean the mess, take control. Bela taped up my cracked rib; if I was careful, I could do most regular chores.

Before we went to work I held her and I stroked her hair, her shoulders. Then I put her out at arm's length so she could watch my eyes, my mouth.

It's tricky to see you well, I said, what with such a stream of diamonds coming off your face. I hope those Rooskies didn't step on my sunglasses—I think I'll need them if I am going to be around your beautiful smootchie all day.

And we hugged and I made myself promise not to think about anything hard or dirty or skewed for the rest of the day.

{ *Sometimes I think you were switched at birth with the kind of men* }
{ *who plowed the plains, chopped wood, had four Mormon wives.* }

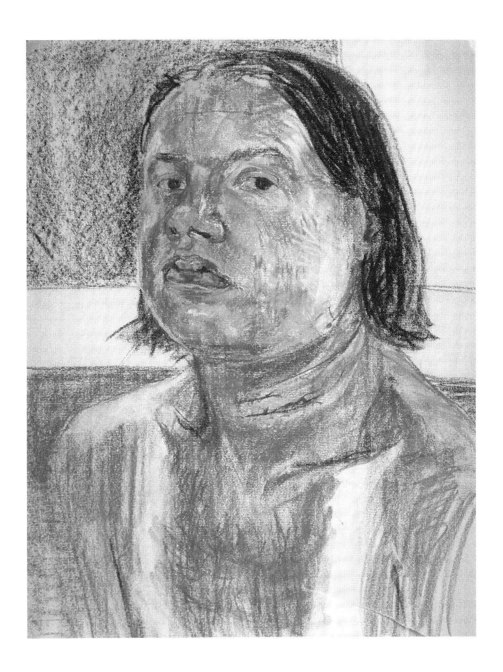

34.

And I still thought I could nail it. As they say about gymnasts in the Olympics, *and she sticks the landing.*

More where that came from, this place is a K-Mart of elephant teeth, just give me a few days, I told Bela. It will be okay. I think I can do this.

She tried to look convinced, but it wasn't working.

Hey girl, I said. Want to know something about me? I had my back to her.

What.

My face was still turned, hands busy.

I said, when I was a kid I would lick dimes and stick them on my nose. I wanted to be as silver as the Virgin in a Mexican church.

Yes, she asked, unsure.

Scout's honor, I said. I turned and faced her, dimes on my forehead, on my nose, stuck to my cheeks and chin. I held up my hands,

silver dollars in each palm.

Look, I said—American stigmata.

{ *If I were on a chain gang, every swing of the maul, every stone I broke would be just to make a perfect island for us to live on, white granite, maybe in Greece, maybe somewhere with bioluminescent waterfalls.* }

35.

The next day I found a plover egg, speckled brown on blue, carried it back three miles for her, balanced the whole way two inches above my outstretched palm.

Pretty good if I do say so, especially since I was listening for bones at the same time. As my grandma used to say, put that in your pipe and smoke it, mister smarty pants.

{ *We no longer looked like ourselves: we looked* better *than that.* }

36.

At first he just stood there.

Crash, Uqi said finally. They go, gone, have all crashed, the helicopter police. Done, finished.

He made a motion like wadding up bad paper.

Before the horse police get there, I will take you. Now, hurry. Please. We will go.

Yes.

{ *I still think doorknobs sing magic words.* }

37.

No magic tundra flying this time, but we loped along with a strangely exhilarating gait, the three of us covering ground with an effortless pace that made miles fall behind like flocks of small birds. After some indeterminate blur of miles and hours we came up over a small hill and stopped to look down on a wet, meadowy area, an oval whose center revealed a splayed mess of helicopter and scorched moss.

Holy shit, Bela said. Holy mama of Jesus.

It looked like a pretty mean wreck. *Red asphalt*, as my high school driving instructor would have said.

Bodies, I asked—are there bodies here?

No, he said. Gone. They gone them away. Two machines crashed, but one after that could still fly. They tied the dead in the good helicopter, went away in that. No alive bodies, no dead bodies.

The debris field stretched ahead of us. Somehow on Uqi's run we had circled around to come in from the top, from the direction they had been headed; whatever went wrong—had they been shot down with a small rocket?—had first happened behind them about half a mile. In hound-dogging back along the flight path we found enough salvage and wrack to open a small store: several helmets, a canteen, a bottle of vodka (unbroken), yellow cargo strap with frayed edges, a belt buckle, eyeglasses, a piece of a cockpit door, a glove full of wet dirt that I was afraid had a human hand in it. Wallet full of wet rubles. Shreds of torn pages, including half of a water-stained edition of *Playboy*, but in Polish, not Russian. Maybe Miss Warsaw was better looking than the models from Volgograd. It was Bela who found what I assume Uqi had known about all along.

Tusks. Ivory. The stolen treasure.

Not just ours, it turns out, though it was easy enough to know, but two other, smaller ones, one that was just a broken piece and one that was complete but hardly taller than me. Bela had the broken one and was lifting it up and down like a barbell, grinning and hopping. Even Uqi had a smile for the luck of it all.

They will be back, he said. This is not done. An hour or a day. Coming back.

Yes.

We must go.

Yes.

We hammered a sled out of bent metal, knotted harnesses from webbing, and in one long day of hauling, made it all the way to the cabin. Sometimes even the sky feels like it is on your side.

{ *You called me Dobbin and I told you no, my name was Princess Petunia.* }

38.

Neil Young—

There is a town in North Ontario,

all my changes were there.

My father had a shoebox of odd bits: foreign bills, cap badges, buttons and glass beads and loose coins from all over the world.

Why, I kept asking him.

He finally said it's my change box. Whenever I want to make a change in my life, I have to put in money, to pay for it.

That's stupid.

Not so stupid, he told me, as staying the same all your life.

{ *Drachmas, doubloons, dinero, dosh. You are my wonga queen.* }

39.

I thought I would miss my mother when I was in Russia but it was no different than usual, just a dim ache, like an infected tooth. It never really went away.

What I did miss was Starbucks.

I've always wanted to be normal but dreaded what it would mean. I don't think I really wanted it to happen, not yet anyway, but I knew it was inevitable. That night the antler wife came to me in my sleep. It seemed that she kissed me, held me, but with a tender and strange caress—it was like a reverse form of resuscitation—and I knew, in my sleep and after, that she was taking away from me the ability to hear bones talking to other bones. It was like being whittled or undressed.

The next morning I woke up as deaf and mute as anybody else.

{ *You will never be brown bread. You will always be food for the moon.* }

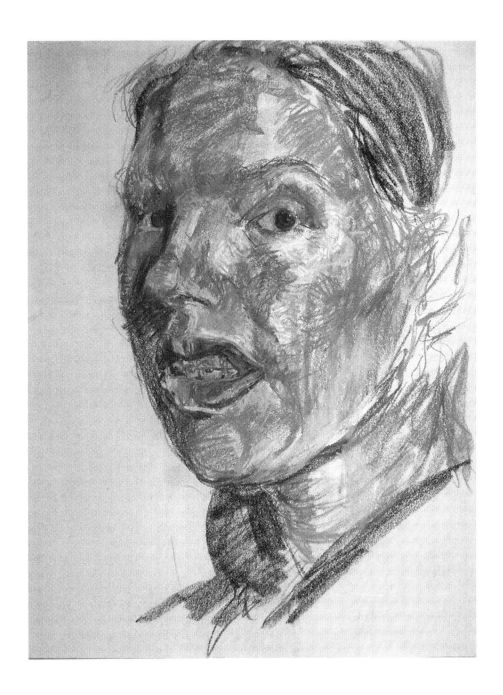

40.

We left. After a week we got to the right place and could take a boat to a town, and from that town we took a boat to another town, and then a bus and bribe and more bribes and some dodgy flights to gravel airstrips. More as joke than code we called the tusk Baby, and the bribes that went out, Baby Food. In the end we had to sell all the pieces from the extra tusks, just to be able to afford to keep the first one.

Cost of doing business, Bela said. Baby's hungry.

One thing about her. She sure as hell knew how to forge convincing looking papers of origin. You want to cook up a batch of dog-eared, well-stamped export permits? Give her a xerox machine and a box of colored pencils and she could walk a box of the Tsar's fine china right off the loading dock of the Hermitage.

{ *Lying well is a just a job like any other.* }

41.

One guy, our last stop at the freight office, we were almost ready to board, he was being such a dick. Not for money, just to do it, because he could. Men can be such assholes.

When we got to Moscow she said, do you want to go back to that bar.

She was serious: she was trying to find a way to give me what I thought I wanted. She knew, of course, about that stupid hookup. Bela had known within thirty seconds, had known all along, had known for the whole trip.

{ *Honey child, I knew about it before it even happened.* }

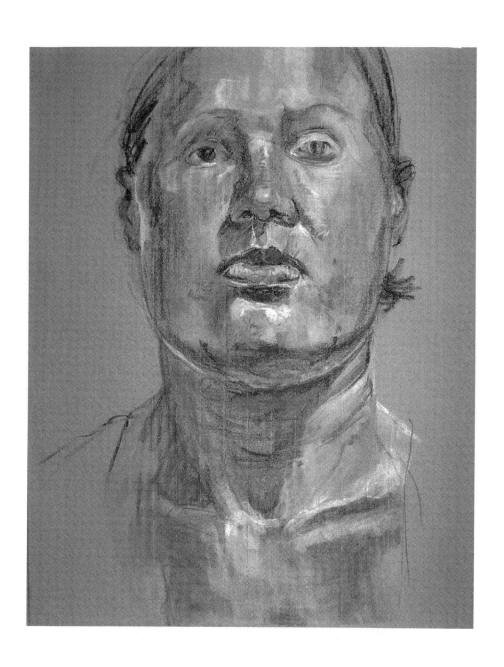

42.

Frankfurt Airport in the rain: layovers until our itinerary caught up with our bodies. Once Baby arrived we would confirm final flights.

The world staggered us. In defense I wore makeup, a costume paste of oil and color, turning my mouth into *mouth*, changing my eyes into blue-rimmed caves of wonder. Even my ponytail seemed less like a fact or convenience and more like the tribal accessary of a horse guard on parade.

We ate salad and bratwurst and bought peach-colored scarves just because we could and even took topless snapshots in a photo booth, curtain drawn, 3 euros each. She bought foam earplugs: Bela hates crying infants more than I do. Police with vests and radios kept track of the crowd, patrolling with casual menace. I always wonder about these displays of force. They would be more useful if they carried not automatic weapons but just some spare nappies for the tired women from Turkmenistan with headscarves and too many children. A free, state-sponsored pram service, how about that? Somebody just to help keep track of the grandmas or to give tired babies a push around the escalator entrance. Bela had to explain to a perplexed babushka how the bathroom's automatic faucets worked.

Maybe this is what limbo is like. We killed half an hour making fun of the public announcements, trying to outdo one another for whose repeated version was more garbled.

Bela tried to kiss me and I turned around, coy—no, you'll ruin my lipstick.

She tried again.

No, I said (robot voice), this mouth is a notification-only server. It does not. Accept. Incoming. Replies. It is for informational email only. Do not reply to this mouth.

If only we had some sidewalk chalk, Bela said, we could make hopscotch.

We chewed bright pink gum and shared a seat to cruise the web. Being in Germany made Bela hung up on World War II; she wanted to know what was the last photograph ever taken of Hitler, which I told her was morbid, verging on immoral. Still, of course, there was a website—there always is—Marilyn Monroe, Princess Di, Hitler, a journalist who had died covering the 9/11 bombing, the last photographs of Abraham Lincoln. There always is somebody eager to sit at the head of the vampire table, napkin tucked into shirt, knife and fork upright and ready.

What will be our last picture together, she asked.

A man next to us had his iPhone out, was holding his arm up and taking a picture of his wristwatch. Maybe his flight was really late: customer relations at Lufthansa was about to get a very angry email, backed with photographic evidence.

Him, I said—he just took it. We're in the background. Our last photograph.

Bela sucked in an *oh* of breath, was reaching for my hand when the windows blew out.

We saw the explosion's blast before we heard it, glass going everywhere, then the smashing noise of the explosion, the force of it, me holding Bela under me as I covered her with my body, just one blast, the lights gone out,

alarms, screaming, screaming, waiting for a second one, is that it?, just one?, holding her so tight under me my hands would leave bruises. She was a small wet brown animal inside me, under me, pulled into my protective warmth, both of us bleeding by now from the glass, people screaming, the shouts of the police, no more explosions, just the one, me keeping her under me as I crawled towards the exit, eerily orange through the smoke and the bodies. I could see a sign, AUSGANG, stayed low, crawling, others going there too and what was surprising was how calm we all were. It was less like some terror thing and more us all just playing along with a macabre piece of performance art.

The door was already open, we made it, people rushing but helping each other too, some stairs and both of us up now, holding hands, emergency lighting on, we ran with the others downstairs and out to the open night air, on the ground now, a rainy baggage loading area maybe, tarmac and cloudy night sky and a glow of smoke coming out of the open window holes of the blown-open side of the building. *Whee-haw, Whee-haw*— emergency truck sirens, a sound coming in and out of the landscape as if there was something very underwater about my hearing.

Crying and shaking we touched each other all over: dirty and sharded by small cuts, but nothing bad really, both of us okay, the hearing thing a bit odd, shaking and rubbing streak marks of tears off of our faces. It's okay, I kept saying over and over, it's okay, you are okay, it is going to be okay. Everybody kept moving and we did too.

Quick checks: she could still run, we both could, and I hauled her after me like a reluctant dog, saying quietly, firmly—come, come now, Bela, *please*, run, NOW. Even though there was a finely stinging rain—I remember vaguely wondering if it would help put the fire out, inside the terminal—it still felt like the time on the tundra with Uqi, going to the helicopters.

We didn't expect it and I had not heard it coming, but Bela and I each had somehow a final, perfect sense of buoyancy, a surge of long-distance effortlessness.

We got away from the other survivors almost immediately. No gunfire, nothing else, it might have been a bomb or maybe something just more random, a fuel truck with a bad spark plug, could have happened anywhere. It was cool but not cold, and the rain somehow was an important part of our escape: I felt like it was covering our tracks, washing away traces of our passing, even though we were on pavement. Whatever was back behind us in sirens and smoke and people wrapped in blankets, whatever was there might follow us, and I wanted us to get away, I just wanted to be far, far away.

We ran easily and well, dreamland athletes in a tragic, magical movie. Warehouses and parked trucks locked and dark, and some side paths, and finally an open gate, passing unchallenged and unseen through the layers of wire mesh security fence and onto a side feeder road, no traffic (was it just Sunday lull or had the area been sealed off?), me no longer urging her on, both of us running together, side by side, running as if this were the Kenyan highlands and this all had been just another twenty-mile training day before the next stage of the Olympics.

We stopped inside a scrim of woods wedged between a silent industrial park and the dark, lumpy flatness of a recently tilled field. Hands on knees we were both leaning over, throwing up. The air smelled like our vomit but beneath that, another layer of smells, the night air wet and good, like a rich, lush potting soil. My ribs hurt like fire.

Holy fuck, Bela finally said. What just happened? What was that?

That was nothing, I said. That was somebody smoking a cigarette too close to a fuel truck, or that was some Aussie kid's backpack with a propane camping stove that got leaned against a heating vent. I don't know. That was just the world, busy being the world. It was nothing. It had nothing to do with us. It is over, gone. Done.

We were wet but hugging, breathing hard. It had stopped raining. She wiped my mouth with a kleenex.

Bela said, oh sweetie, your makeup, and then, Sweet Jesus, Trouble really is your middle name.

Hey, this one wasn't me, I complained. I am just a girl waiting for a ride.

We had our money belts still, quite a bit of baby food in both—a quick survey showed we each had at least five or six thousand bucks in American dollars and euros, probably more—and we still had our passports, our credit cards, even some miscellaneous museum ID cards. One working wristwatch, one busted one. A rather good fountain pen. We had lost both our backpacks, but that was nothing. There were more copies of *Smithsonian* magazine and little baggies of foam earplugs where those came from.

We have a lot of final pictures yet to go, I told her. Too soon now to say that was our last one. Remind me to apologize to God for tempting fate. I never should have said it. So. Jeez, are you okay?

We kept touching each other. Cuts here and there, mostly okay. My left leg had the shakes but oddly the right one was okay. Strangely and newly modest, Bela made me turn my back while she squatted to pee.

Through the woods we could see the glow of the airport, smoke, emergency lights. It looked like a large, garish theme park, the opening night at Volcano Land.

Something came to me—hey Bela.

Yeah?

Ever seen *Casablanca*?

I could feel her smiling, even in the dark. Only about fifty times, she said.

Well, Louie, I have the feeling that this is the beginning of a beautiful friendship. The money you owe me for saving your ass just now should just about get us to Brazzaville. I could be induced to arrange a passage. Shall we—?

Her turn now to let time grow thick between us, waiting.

{ *We shall.* }

43.

One of my father's routines:

Hello, room service? I would like to order a room.

We holed up three days. No official explanation about the bombing. We slept and ate and held each other. We had even more money than we had guessed. Finally we bought new phones and began to make the rounds. No work for us in London or Berlin but the Boston Museum of Fine Arts had temp slots, so we rerouted: by train to Munich to meet a bargain flight for Logan, more cooked up manifests, air freight and Business Class, Baby and us, same lives, same plane, just different boxes. All seemed fine.

Seem is not the same as is.

Baby was confiscated by U.S. customs and it's a good thing Bela had used about eight layers of fictitious names on her paperwork or we would have ended up confiscated with it. It just seemed so damn unfair. I tried to put my fist through a wall and so we spent a night in the ER.

I think Bela was more pissed off with me than the situation. Jesus, she said. Now I have to deal with your smashed-up hand? Can't you just grow the fuck up?

You first, I said, and felt even stupider as soon as I said it.

Bela must have felt sorry for me, since she dialed it down, saying, hey Chica, ever seen *Casablanca*?

Only about fifty times.

Show me your hand. Yes, sure, you look like Victor Lazlo getting his hand bandaged in the bar after the goons break up the Resistance meeting. Now let's go home, go to sleep. You're never not beautiful Chica, but I am ready for us to both to go and be beautiful in the dark.

Yes. I'll drink to that.

{ *Let's all use our inside voices now.* }

44.

Boston felt good, felt almost normal. We felt almost normal. Winter was coming but the work was steady and we had a view of the river.

Some days we had to pretend pretty hard to fit in—

smoke, car alarms, loud noises gave us both the heebie jeebies. Bela went to survivor support groups, said it helped. I just made sure I had my drinking on a choke chain, though there was one bar, this guy was being an asshole just this side of impossible, he said to me, So little lady, howd'ya hurt that hand of yours?

I looked him up and down, and before I could stop doing it, said, *Fisting your mother, asswipe.*

Bela said later I needed to go easy on the soft ones: not their fault Baby went the way rainbows and pixie dust.

And most days sailed by fine. I held it together, went a full month, only said shitty things to Bela five times total, felt bad as soon as I did it. She pretended she had not heard. We were getting along as good as anybody we knew.

{ *As the man said, God finds our desires not too strong, but too weak.* }

45.

One night clearing dishes I said, what do you want to do for a dessert? No answer, I look over, Bela has her bare feet on the table like Gandalf and Bilbo smoking pipes, she had got a bottle of children's bubbles, was sitting there, deadpan, blowing huge, shimmering soap bubbles with the little round plastic wand.

She was really good at it too.

My father wrote a check each week for the offering at church. He always made it for a little more each time—just in case we need help, I want the Big Guy to remember us, he told me.

46.

How to eat a grapefruit:

First, study history. The orange tree, so many miles, China to the Levant to Spain to the slave colonies of America. One must cross pummelo with Seville oranges, grow a cannonball-sized fruit, ugly and bitter. Planters in Florida and Texas (and California and Arizona) must lose the Civil War, stay in the Union, connect up via Eisenhower's interstates with the markets of the bleak and snow-grit granite Northeast.

Next, buy the best and largest, bring home, let ripen two more days.

Cutting it in half:

the anticipation of color.

Is the flesh going to be grenadine, pale as fresh lemon, or blush-wine pink?

Next, laying out the tools. A spoon perhaps, or knife and fork? Several blades, sharp and angular. Small blackjack, for threatening the seeds.

Pith and rind must be dealt with, flesh flensed from hull with swift digs and swipes. Arrange artfully in a bowl, glowing segments, all waiting for their gloss of honey. Nobody eats a grapefruit; the flesh is merely the delivery mechanism for sage honey or golden-brown sugar, or at worst, a hurriedly slurried dump of plain white C&H.

Repeat until full, with toast and coffee.

Best done in company, Vivaldi's *Four Seasons* on the loop tape, windows steamed up so bad you can't see out for nothing.

The pink flamingo on the porch pressed against the glass, looking in and trying to make out what all the fuss is about.

{
I am writing a book, Mermaids of the Great Basin.
You, my love, swim across on every page.
}

47.

We give our partners good things and bad. If you have a cold, odds are your wife or boyfriend or roommate will get it too. We all know how fast AIDS spread. What if I didn't inherit the pencil-across-the-table thing, but just had learned it? Could I teach Bela? Could she then give me the mind-meld Jedi thing?

Tricky to bring up. This is not one of those, *do you want to roll a spliff*, or *have you ever wanted to explore kinky sex* kinds of discussions. There's no website of instructions for people for whom reality doesn't quite work right—

not one that doesn't involve shock therapy or a bottle of small, carefully prescribed pills.

I know, because I have looked and looked and looked.

{ *We sang it in church: "Make me salt, make me light / let me Your holy fire ignite."* }

48.

Justice, I suppose?

CNN: *The German government said that* _____ *carried out the Frankfurt bombing, a splinter sect directed by* _____ *and funded by* _____.

This week _____ *was caught; security forces knocked down the door of* _____ *and killed seven, wounded two, with no loss of their own.*

Mostly sounds and words, words kept in file folders marked DUE PROCESS. Draw a box called reason, step inside, have somebody sit on the lid. Still won't help things make any more sense.

{ *Let Talking Heads sing it true:* Same as it ever was. }

49.

In Russia, if Bela had found a pear, just one, growing in the tundra from a magic pear tree, she would have brought it back for me, a gift.

If I had found one, I probably would have eaten it.

But I was beginning to make a plan. It had started two days before, when she had texted me. We only worked one floor apart but didn't hang out at the museum. Our texting was constant, and some of it not even dirty. She wrote this, no more, no less:

Five toes and slightly larger than a cat describes a kind of fossil horse. What would you give to have one, dappled or with thin stripes, as a backyard pet?

Alcoholics are taught to be diseased, tainted, the rest of their lives. Felons can't vote ever again. We like labels. *You are not what you eat, but what you once were.* Can people change? After all, queers can't be bullied and therapied into being straight.

My Indian name will be Old Wolf Dog That Learned Many New Tricks. Watch me change. The old life is done, just because I say it is—close the drawer, turn the key, and it's put away, finished. It will be cartwheels and daisy chains from here on in.

{ *From the diving board, the glass of water looks so small.*
We don't need a bigger target, just more practice running with our eyes closed. }

50.

We called it huckleberry honeymoon. One day I got home, no Bela, then she called.

Where are you?

At the bar down the street—and she said she was wearing a new dress and LL Bean boots and nothing else, would I come walk her home.

Oh my snickerdoodle. Hell yes. Who knew it would last this long?

Maybe I just had been on the reverse of the equation. If you wanted to do cocaine, you didn't plant coca bushes from Alewife to Braintree, you just grabbed a wad of twenties and went to Harvard Square and scored. We had been on the wrong end of the supply chain. Middlemen, that's what America is all about. You want mammoth ivory? No problem. A guy will always know a guy.

I had to talk to the Chinese, but in the end, okay. Bela came home and I had wrapped it in yellow paper, had made a bow out of blue polypropylene line. The presence of the tusk filled the room, strange installation, impossible sculpture, fallen redwood branch wrapped up for Christmas.

Bela's eyes got big, like she was wearing Mr. Magoo glasses.

It isn't—. How did you. It can't be.

You bet your booty. *Open it.*

Even I was laughing as we tore the paper off together, ran our hands over the cool, oak-dark surface, measured it with our arms. She said, it's even better than Baby, how did you do it, oh my god, oh my god.

Later, after sex and selfies and Sam Adams, after we had had picnic dinner under it and after Bela had rubbed it with linseed oil and chamois, it was time for her to ask what next. This time, I was ready.

Here's my plan. Piece of bone like this, it needs a house.

Yes, she said.

Between us, we are making some money.

Yes.

Well, what comes next then is all the usual what-comes-next stuff.

She looked at me, unsure.

This part I had rehearsed.

Buy me a used piano. Buy me a goldfish. Let's carve the tusk into a spiral of vines and blossoms, make it the doorway to our bedroom. We'll take ballroom dancing lessons. Every day I will wear a different carnation in my hair. I will make you a skateboard with the Virgin of Guadalupe on the top and bottom. Whenever we're mad at somebody, we'll talk smack in Russian. We will name all our U-Hauls "Rocinante." We'll bowl all day every Sunday until we each get six strikes in a row. We will buy telescopes and hunt for comets, and then when we start to find them, we'll name them for each other. So come on, you ready to bet on those odds?

But she had a surprise of her own: stolen or just a good forgery, I never asked, but she handed me something small, wrapped in tissue.

It was an Ice Age figurine, ivory, worn smooth, small as a thumb. Breasts and vulva, as female as could be. It looked like some of the pieces that are in the Hermitage—charms to ensure pregnancy or a type of proto-pornography, circle one.

Bela's possum smile.

We're not done she said, arranging a bottle of alcohol and pads of gauze and the scalpel she sometimes used for cleaning jewelry.

She sat on the floor, stretched my arm out, palm up. She stretched hers out parallel to mine and cleaned both of our arms with alcohol. With a lighter, she sterilized the knife blade. When it cooled, she made a small, precise cut on the inside of her arm, half way between wrist and elbow, and waited as the cut welled up a small bead of impossibly red blood. She held my arm steady, looked at me, and made the same cut on me.

She then pressed the two cuts together, blood locked into blood.

With this kiss Chica Paloma, I thee wed.

Is that it then, I asked. No rings?

No rings. That is it.

What if—

But she shushed me, two fingers on my mouth. Listen, she said.

My eyes asked her, to what? There was nothing there.

No, *listen*—

And I realized, it had come back. Maybe it had been there the whole time and Antler Wife really had been a dream, nothing more. I could hear again, it spread like circles going wider and farther the more I tried. I heard the children next door. I heard the heater come on next door too. I heard something in their sink settle deeper into its bath of soapwater. I heard two doors open, two doors close. I heard a seagull, hungry and complaining. I heard trains crossing deep beneath the river. I heard Bela's breathing.

I heard airplanes taking off for Canada.

I heard the new tusk, humming slightly.

I heard more airplanes, cockpit chatter and an attendant, getting a man a pillow.

I heard the blood geysering up into the canopy of my head and swirling around and rushing back down again.

Bela took her hand away, saying, that right there, that was the symphony I just wrote for you, and guess what, it has many movements—at least 10,000 more, and each new movement lasts one full year.

Thank you but I still might want a dog, I told her. Maybe two or three. And I just get uglier, the older I get.

Bela said, Chica, honey, you know how things slip for you? You are never quite sure when you can trust stepping onto the thin ice of the world? It

happens to me, I think it happens to everybody. The main difference is, for me, whenever we are together and that happens, unlike you, *I don't mind.*

She was smiling now. If a mermaid gives you a magic hat, she told me softly, you can breathe even under the ocean.

Bela, if some mermaid I don't know gives you a hat, I will slap that bitch silly.

Just listen, she told me. Are you listening?

Yes.

And then she did it: she held her hand out, fingers stretched, like she was counting to five, and made me hold mine out matching hers, and she said one of Uqi's words, and both of our hands—painlessly, effortlessly—lit up like candles, the fire strong and sure. I shuddered, started to pull back, but she told me, without words, she told me clearly, *it's all right, trust me, be in the moment.* I closed my eyes and made the light switches around the room turn off, so we were in the dark, cross-legged on the floor, palm to palm, lit by the glow of our own special fire. I suddenly remembered who could do this, Saint Sebald, and he had once crossed the Danube on his own cloak.

Are we holy, I asked her.

Hell no, you randy little tramp. You're about as holy as a pimp smoking spice.

Are we dead?

Speak for yourself, but I'm not and I don't plan to be, and I don't want you to be either, not for a long time yet.

So what are we?

She didn't answer but blew out the flames and pulled me on top of her. We curled up with each other in the dark. My hand didn't hurt, it just felt good, smooth, a bit numb, like I had been swimming a long time in the ocean.

Well, Bela said softly, according to you we're unicorns with broken horns, hungry for salt. I'll take that, and who's to say you're wrong? Or else we are a kind of angel, but then so is everybody else, even that grim trainer at the gym, the heavy one who hits on you and thinks I don't notice. I know one thing you are, though. I will get you business cards on Monday—*Chica Paloma, Tusk Hunter.*

But I had stopped listening, or rather, I had gone away, wider. I could hear her mouth getting ready to kiss me, and could hear my own breath going in and coming back out, and could somehow even hear the tomorrow-and-tomorrow versions of all that—

until I began to hear her breathing ahead of it actually happening, ahead by a few minutes, then more, hours, a full day,

and then by all the weeks and years

{ *and rain and smoke and comets yet to come.* }

Books should be small, but contain no lies; everything is its own and belongs to that book, down to the last ink stains.
 —Alexei Kruchenykh, 1913

The Kenneth Patchen Award

After a hiatus, the Kenneth Patchen Award was revived in 2012. In the 1990s, The Kenneth Patchen Prize for Literature was a much-coveted prize administered by Pig Iron Press of Youngstown, Ohio, in honor of famous experimental fiction author, proletarian poet, and Ohio native Kenneth Patchen. Beginning in 2012, the Award was reinstituted as the Kenneth Patchen Award for the Innovative Novel, and it honors the most innovative novel submitted during the previous calendar year. Kenneth Patchen is celebrated for being among the greatest innovators of American fiction, incorporating strategies of concretism, asemic writing, digression, and verbal juxtaposition into his writing long before such strategies were popularized during the height of American postmodernist experimentation in the 1970s. His three great innovative novels, *Sleepers Awake*, *The Memoirs of a Shy Pornographer* and *The Journal of Albion Moonlight*, have long been benchmarks for beats, postmodernists and innovators of all ilks, inspiring younger writers to greater significance and innovation in their own work.

About JEF

Founded in 1986, The Journal of Experimental Fiction is the English language's pre-eminent source for innovative fiction.

Other Winners of the Kenneth Award for the Innovative Novel

2015 – Kate Horsley – *Between the Legs*
2014 – Bob Sawatzki – *Return to Circa '96*
2013 – Moore Bowen – *Oppression for the Heaven of It*
2012 – Carolyn Chun – *How to Break Article Noun*

A checklist of JEF titles

Made in the USA
Middletown, DE
10 September 2017